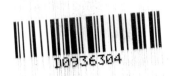

FRED WILLIAMS

L | A | LOUVER

LIBRARY OF CONGRESS
CONTROL NUMBER: 2005901659

ISBN 0-9765585-1-3

ALL IMAGES © L A LOUVER 2005

THIS BOOK WAS PUBLISHED
BY L A LOUVER ON THE
OCCASION OF THE EXHIBITION

FRED WILLIAMS
THE LATER LANDSCAPES, 1975 – 1981

8 APRIL – 14 MAY, 2005

catalogue design:
JAEGER SMITH | LOS ANGELES

photography:
PAGES 15–47, ROBERT WEDEMEYER

printing:
TYPECRAFT, WOOD & JONES
PASADENA, CALIFORNIA

L | A | LOUVER |

45 North Venice Boulevard, Venice, California 90291

TEL 310 822 4955 FAX 310 821 7529

WEB www.lalouver.com

ADAA member

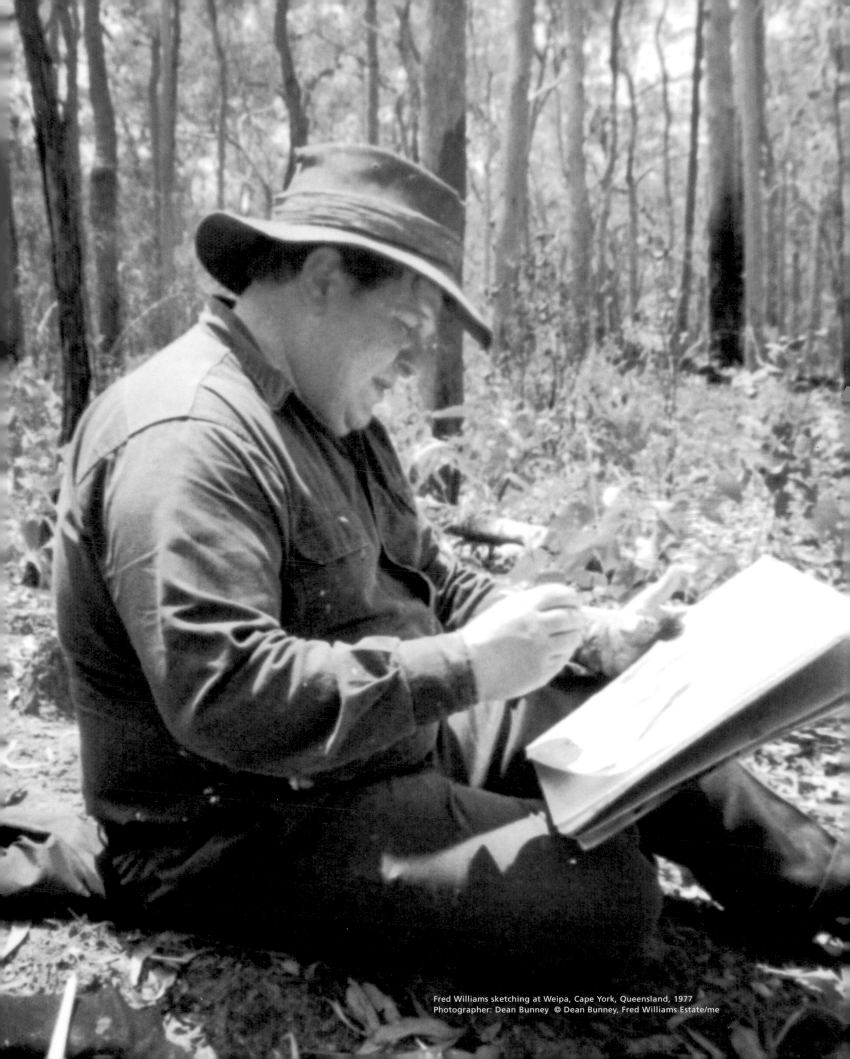

Introduction

I was introduced to the work of Fred Williams in 1979 by an English colleague, the late Cavan O'Brian. At the time, I was in the process of expanding my work as an art dealer beyond the representation of artists from Los Angeles, and the United States at large, in order to be able to contextualize the activities of the gallery from an international point of view and, at the same time, broaden the range of our audience. Cavan O'Brian was a director of Fischer Fine Art who represented, within the context of other 20th century interests, a number of important artists such as Leon Kossoff, and was beginning to work with Fred Williams from Australia.

Knowing my love for painting, Cavan considered this introduction to be a match. Sadly, shortly thereafter in 1982, Fred Williams died prematurely, at 55 years of age and, regrettably, I had been unable to experience Fischer's solo exhibition in 1980. While Cavan made certain that I received a copy of *Fred Williams* by Patrick McCaughey[i] and *A Singular Vision, The Art of Fred Williams* by James Mollison[ii], and although I was periodically reminded about the work by paintings on view at the Tate Gallery in London, or at the Metropolitan Museum of Art in New York City, it was not until my first visit to Australia in 1998 that I was able to experience

a representative body of paintings. My first viewing was in Sydney, at the Gallery of New South Wales, in Canberra, at the National Gallery of Australia, and in Melbourne, at the National Gallery of Victoria, whereupon I became completely convinced. As you will see from the enclosed selected bibliographical listing, the work of Fred Williams is widely appreciated throughout the Australian continent, and can be viewed in all of the major museums in Australia. In fact, in his country of origin, Fred is considered by many other artists, collectors and critics[iii] alike, to be their greatest painter of the 20th century.

It is therefore with great pleasure, and a sense of accomplishment, that we have been allowed, by Lyn Williams and her family, to organize this exhibition, "Fred Williams: The Later Landscapes, 1975-1981." In this way, L.A. Louver Gallery has been given the responsibility to contribute to the wider international appreciation of his work. We are privileged to join in the company of those venerated institutions, to which I have already referred, together with the Museum of Modern Art, in New York, the Serpentine, the Hayward, and British Museum in London, who have, through acquisitions and exhibitions, supported the work of Fred Williams outside Australia.

My admiration and appreciation also goes to Lyn Williams, who has been a tireless supporter and champion of her husband's legacy. The intellectual rigor and tireless energy with which Lyn Williams has approached the challenge of representing the work of an artist who rarely traveled beyond the landscape of his chosen subject and solely committed himself to his art and that of his countrymen, is an example to be followed. I am also eternally grateful to Patrick McCaughey, for finding the time to step aside from his independent studies and curatorial adventures, to write such an insightful essay for this catalogue. It is clear to me that Fred Williams produced some of the most original and timeless paintings of the post-war years. I do hope that you enjoy this exhibition, as much as I have enjoyed the process of its organization and presentation.

Peter Goulds 26 FEBRUARY 2005

[i] *Fred Williams*, by Patrick McCaughey, Bay Books, Sydney, London, 1980; revised edition Murdoch Books, 1996

[ii] *A Singular Vision, The Art of Fred Williams*, by James Mollison, Australian National Gallery & Oxford University Press, UK, 1989

[iii] *Splendid Isolation: A detailed immediacy provides new reasons to fall in love with Australia's greatest painter all over again*, by Sebastian Smee, The Weekend Australian, Sydney, pp. R14-15, January 8-9, 2005

Cover image: Fred Williams in his studio, 1980
Photographer: David Verrall © David Verrall, Fred Williams Estate/me

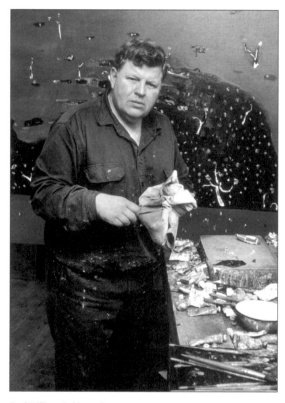

Fred Williams in his studio, 1981
Photographer: Rennie Ellis © Rennie Ellis, Fred Williams Estate/me

The Later Landscapes
of Fred Williams 1975 - 1981

BY PATRICK MCCAUGHEY

EARLY PHASES

During the 1960s, Fred Williams established himself as the leading painter of his generation and earned his lasting reputation as one of the handful of major artists produced by Australia. He had an original vision of the landscape, a sophisticated understanding of pictorial form, and a demanding sense of the painter's calling. It did not matter whether you painted in Melbourne or Manhattan, London or Los Angeles; the artist had to measure up to the best of both the past and the present. Nothing else would suffice.

It may surprise today that Williams should have achieved this standing in the boisterous '60s through such a traditional pursuit as landscape painting. In Australia, however, the landscape has a hold on the imagination of artists, no matter whether they are indigenous or those who came after white settlement in 1788. The place is so big and so sparsely populated, at once so full of promise and so inhospitable, that it makes its presence felt to the most casual observer. The irony is that the overwhelming

majority of the population lives in large, sophisticated cities, which cling to the coastal littoral, leaving at their back the vast hinterland of Australia. Curiously, the situation exacerbates the presence of the landscape. Australians have coined the generic term, "the bush," to describe their landscape. The bush can refer to farming country, as well as eucalyptus forests, to mountains and deserts, the near and the remote. The bush is everything that is not the city.

A generation of gifted artists immediately preceded Williams in Australia. Seen at their best in the work of Sidney Nolan and Arthur Boyd, they sought to comprehend and bridge the disparity between the vast scale of the landscape and the diminutive human presence within it through allegory. They took representative figures from Australian myth, folktale and history, and pitted them against or embedded them within the landscape. Nolan found in the doomed outlaw, Ned Kelly, or the lost explorers, Burke and Wills,

representative types of the Australian experience. Arthur Boyd memorably painted a series on the love of a half-caste for a white bride, and frequently placed biblical scenes in the Australian bush. Adam and Eve could be expelled from an antipodean Eden on the Mornington Peninsula just outside Melbourne. These allegories gave imaginative purpose and significance to the Australian landscape: it became the arena where profound acts of human aspiration and suffering could be acted out.

Fred Williams knew these artists and their work. Deliberately, he chose to "admire and do otherwise." Their romantic quest for myth and meaning could not be accommodated within his pragmatic, even tough-minded view of painting. He was better schooled than the earlier generation. After extensive training at the conservative National Gallery of Victoria Art School, he spent six years in London in the early 1950s where he attended part-time both the Chelsea Art School and the Central School for Arts and Crafts. During those years he saw and absorbed much modern and contemporary art. Naturally reticent emotionally, he was drawn to the formal, abstract qualities of 20th century art and applied these principles vigorously and robustly to the Australian landscape on his return in 1957.

Williams found his voice as an artist in response to the distinctive but unspectacular landscape around Melbourne during the 1960s. He painted in a beautifully modulated tonal manner, using higher keyed colors sparingly but dramatically for lustrous highlights. Occasionally he would cover the surface with a rich, monochromatic hue on which he hung his distinctive notations of the dry plain and the featureless, repetitive bush. He worked in series, sketching mainly in gouache and occasionally in oil, directly from the motif, and then working these sketches, sometimes through a progression of oil studies, into full-scale paintings in the studio. Although he named the series after various locations such as You Yang landscapes – a group of stony, scrubby hills southwest of Melbourne – few paintings in the 1960s were of specific sites or locations. He disdained the idea of painting "views" of the landscape.

By 1969-70, Williams painted his most abstract works: large fields of dun-colored grounds, divided by vertical lines and relieved with specks of color. He called them simply Australian Landscapes, espousing his surprising belief that all Australian landscapes shared the same basic properties. Fred Williams in the early 1970s stood pre-eminent in Australian art, admired by both his own and a younger, emerging generation. At this moment, he felt strongly and acutely the need to change the direction of his art. The minimal Australian Landscapes had taken his art to a point of refinement from which no further progress was possible. Color would be the chief agent of change. He extended his palette to a wider range of hues than he had permitted himself before. It transformed his art and ushered in a decade of unparalleled creative – even furious – activity before his death in 1982 at the age of 55. His new palette and the new range of subjects it opened up surprised, even shocked, his admirers. In 1972, Williams was an artist reborn. The paintings in this exhibition provide a brilliant picture *in nuce* of the "new" Williams of 1975-81.

THE CHANGE

Fred Williams' will to change the direction of his art was paramount, and an increasing variety of landscape experiences hastened it. In 1971, he painted in the Queensland rain forest for the first time. The following year, he accepted a commission to paint murals for the new Adelaide Festival Theater and agreed to paint South Australian subjects. He chose the River Murray, slicing its way through desert or near desert country. During the period 1970-73, Williams painted a plethora of marine

Reading in the sitting room, 1976 Photographer: Lyn Williams © Lyn Williams, Fred Williams Estate/me

subjects, which he had previously only done sporadically. All of these experiences contributed to his decision to explore a new and more vibrant array of color than ever before. It liberated his art and his imagination.

Hitherto when Williams had worked directly from the motif, his chosen medium was generally gouache – watercolor reinforced with body color. He used the medium freely and quickly, providing him with a slew of ideas for later oil paintings. With the advent of the new palette, Williams began to work increasingly in oil *en plein air*. Close observation was the bedrock of Williams' weekly expeditions into the landscape, and he began to observe in color. Williams found that by painting in oil directly before the motif, he could conceive and compose almost complete paintings with little later studio work. The distance between his "outside" work in the landscape and his "inside" work in the studio diminished sharply. This excited him and renewed his confidence. The arduous labor of the studio, which he had never shirked, lightened,

and by 1974, he found himself happily engaged with multiple series.

Williams' renewed confidence sustained him through an initially cool reception to the changed palette. Adelaide, a city of provincial charm and attitude, reacted hostilely when his murals for the Festival Theater were unveiled in 1973 – the first public outing of the "new" Williams. Two years later, when Williams held large and important exhibitions in both Sydney and Melbourne, the response was warmer but muted. Many past admirers were surprised and puzzled by the acidity and heat of the new color, the juxtaposition of the raw and the cooked within the work.

The subject matter of the paintings was changing too, under the liberating effect of the new palette. Large, restless canvases of the dry, scrubby bush would alternate with paintings of enclosed forest ponds, still and secretive. The pictures carried a different burden of feeling than before. It was during his one-man show in Melbourne

in 1975 that Williams began to paint the Kew Billabong series. They reflect a conscious need on Williams' part to find a landscape of retreat.

Two exhibitions that year had taken up much of Williams' time, distracting him from the studio. He had also become something of a public man. Because of his standing in the Australian art world and his reputation as a fair-minded, if shrewd, judge of art and artists, Williams had been invited to join many public bodies, most notably as a member of the Council of the nascent National Gallery of Australia, to which he devoted much time and thought. But he was conscious of the inroads into his artistic practice these public duties made. A week with two or three days taken up with meetings in Canberra or Sydney could be a torment to him, interrupting the flow of work, and preventing him from getting out into the landscape, an unfailing source of renewal for him.

When he found the billabong – a swampy pond that had been cut off from the River Yarra – in suburban Melbourne quite close to his home, Williams was delighted and painted the subject numerous times. An enclosed, horizon-less world, it was the perfect image of retreat and withdrawal. That it was also something of a dumping ground amused Williams. The discarded car tire became a recurring motif in the series. It deliberately counter pointed the lyrical, Monetish delight he took in the gravelly, sandy bank and the murky reflections of the pond. The poetry and anti-poetry of the place, the contained world of light and colour and the residue of human detritus, resonated ironically with his mood. The Kew Billabong series were all painted directly on the spot and lightly edited in the studio afterwards. The resulting spontaneity, of which *Kew Billabong Old Tire II* is a particularly good example, reflects both Williams' delight in finding a place so close to home, and his release from the tensions and burdens

of public life. The iridescent color was both symbol and sign of the new freedom.

Williams went to the landscape on a weekly basis because he drew sustenance from it as an artist. It "triggered" his forms, as he himself once remarked. What makes the later Williams so interesting is that he found these triggers in both familiar and unfamiliar places. The You Yangs had been a much loved painting ground over the years, and more than that: they had inspired his "breakthrough" series of 1962-3. They were a special place for him, "his own country."

Williams returned to the You Yangs in 1975, the same year that he was painting the Kew Billabong series. *Silver Landscape* and *Gold Landscape* are two of the finest products of this renewed encounter with an old motif. Interestingly, when Williams painted in the You Yangs, he reverted to his old, tonal manner. The two pictures share the same site; the bent tree in the foreground and the rocky obelisk on the horizon line figure in both works. Both paintings use the same compositional devices: the landscape becomes dense and knotty at the horizon line and drains to the base of the painting, which is left relatively uninflected to balance the rectangle of the sky. Williams loved to demonstrate how a change in tone could change the feel of the painting and the experience of the landscape. The blue-gray tones of *Silver Landscape*, with its suggestions of a ruffled, cloudy sky, is the cool "winter" version, and the tans and yellows of *Golden Landscape* presents the warmer "summer" painting. Seasonal change is a mild affair in temperate Victoria, and Williams' subtly deployed tonal sense realizes it perfectly. That Williams returned to his old ways when painting the You Yangs points to an artist taking comfort in the landscape. A decade before, the You Yangs had given him a new start. This pair of later You Yang paintings pays grateful homage to a loved and well-learnt landscape. In the 1970s, Williams looked to the landscape both for inner sustenance and for expressive forms. He

needed, however, a more dramatic landscape to absorb the pictorial and emotional bite of his new and luminous color.

THE LANDSCAPE OF OPPOSITES

In the six years that were left to him to paint, 1975-81, Williams' art developed a rhythm of dramatic oppositions in the types of landscapes he undertook: the dry creek bed and the waterfall, the gorge and the mountain, ocean and desert, water and rock. Williams, the most pragmatic and commonsensical of artists, had no plan in his mind. He was drawn instinctively to them. His own comments confided to the diary he kept for the last 17 years of his life deal with the immediate, day-to-day needs and frustrations, successes and challenges of his work. Underneath lay a complex intelligence. The daily entries to the diary gave him a rare self-awareness. He was conscious that his art was changing dramatically and rapidly. But he rarely speculated on the motives or the causes of the change. He became fascinated with the new palette and the properties of color to the point of constructing color charts and wheels. Yet these were largely discarded in the field. He followed his instincts and found himself responding to a wider array of landscape motifs than ever before. Indeed he began to seek out dramatic subjects such as gorges and waterfalls by consulting an old high school textbook, E. Sherbon Hills *The Physiography of Victoria* (1940), and using it as a guide. Where once he had avoided the picturesque motif, preferring the typical, the representative or generic Australian bush landscape, he now explored the exceptional site. The excitement Williams felt before these new motifs stimulated his palette and vice versa. Both enabled him to respond in a heightened key, sustaining the fervor Williams felt personally and imaginatively from direct oil sketch to finished and final work. Whether he was standing on the edge of the gorge overlooking the Lal Lal Falls, or facing limpid mornings amidst the natural monuments of the Pilbara in the far northwest of Australia, Williams was

increasingly drawn to an elemental landscape where the forces, which had shaped the land, could be observed and painted.

Thus the secluded world of *Kew Billabong Old Tire II* and *Reflected Tree Kew Billabong Diptych*, with their recessive space and reflective surfaces, is suddenly exchanged for the wide and open, light and heat filled *Dry Creek Bed*, part of the Gorge series. The latter reveals Williams' astonishing capacity to give the texture of the landscape through paint. By cutting and rubbing back the rich impasto he used when working directly from the landscape, he exactly mirrored the worn down, dried out, drought-like landscape around the creek bed. Williams makes you want to feel and touch what is otherwise an extensive landscape not normally accessible to the tactile senses. The irregular, knotted black line of the creek bed itself shows the path of natural forces through the landscape. Williams makes it the form around which the disparate, fugitive elements cohere – a restless, energetic current running through the painting from top to bottom right.

1977-78 were busy exhibiting years for Williams. W. S. Lieberman, the distinguished curator and connoisseur, later Chairman of the 20th Century Department at the

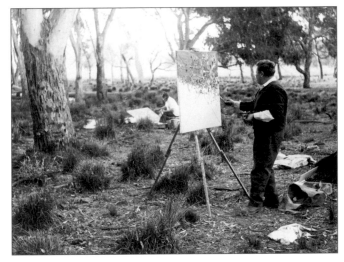

Painting at Yan Yean Swamp, with John Percival in background, 1972
Photographer: Anne Hall © Anne Hall, Fred Williams Estate/me

Metropolitan Museum of Art, mounted a one-man show of his gouaches ("Fred Williams: Landscapes of a Continent," March 11 – May 8, 1977) at the Museum of Modern Art in New York. Later that year, the Institute of Modern Art in Brisbane surveyed his work from 1963-77. Exhibitions of new work in both Melbourne and Sydney took up the middle months of 1978. (Williams found the business of exhibitions – the planning, selecting, hanging, the opening and its aftermath – a terrible distraction from his work.) At the end of 1977, Williams had paid a brief return visit to New York to see the exhibition "Cézanne: the Later Work" at MOMA and went on to Paris to take in a large Courbet show at the Grand Palais. Both would have an impact on Williams' next step.

THE WATERFALLS

The Waterfall series pre-occupied the artist during 1979-80. They were his answer to the Gorge series, although there was some overlap between the two. James Mollison has usefully pointed out a change in materials from one series to another. In the Gorge series, Williams had used "coarse, hessian-like canvas" whereas the Waterfall series were painted on "a fine American canvas…with a texture like fine cotton." With the change in support came a difference in Williams' facture. The rugged impasto of the Gorge series gave way to the thinned paint and glazes of the Waterfall paintings.

After the Kew Billabong series, Williams had found liberation in the wide, panoramic reach of the Gorges. He had clearly taken great pictorial satisfaction and pleasure from the wild and rocky features of the gorges themselves, well demonstrated in this exhibition by *Lal Lal Falls III*. He had enjoyed the drama and the paradox of the landscape that such a wild and mighty world had been shaped in part by the persistence of small watercourses.

The waterfalls offered at first sight a similar theme: the fall of water over monumental rock forms. *Strath Creek Falls III*, one of the earliest in the series, with its more abstract vision of the waterfall-in-the-landscape, follows the gorge theme with the action of water shaping the landscape. (Williams painted at Strath Creek Falls originally out of curiosity. Eugene von Guerard, a leading 19th century colonial artist had painted the falls in 1862. The painting is now in the Art Gallery of New South Wales in Sydney. Williams had known and admired the painting for years, and had even made a free copy of it.)

As the series developed, the atmosphere of the Waterfall paintings became quite different from the Gorges. The waterfalls themselves were often relatively inaccessible and further afield than Williams' customary painting spots, not so readily re-visited. Once there, Williams intensified his observation of the motif and gave to the series a rapt, self-communing quality. Here the later Cézanne working at Bibemus amidst the rocks and trees of the quarry resonated with Williams. It was the same enclosed but monumental world of elemental forms. But where Cézanne tracks the brilliant light and heat of the south of France, Williams gave the waterfalls the lustrous cool tones of indigo and purple. Although the series would contain one of Williams' most monumental statements, *Waterfall Polyptych 1979* (Art Gallery of New South Wales), the intimacy of the series is its most striking quality, exemplified in the present exhibition by *Pool at Agnes Falls II*. The dark pool between the slab of the rockface and the dry bush is like a way into the landscape, reflective and mysterious. The painting has a quiet, introspective quality – such stillness, save for the fall of water into water.

The fact that most of the waterfalls were well off the beaten track added further significance. When Williams and his painting companion, a young Melbourne artist, Fraser Fair, found the falls, there was a small but real sense of discovery,

of coming upon a hidden spring in the bush. The waterfalls took on a dual character: they were both the source of streams and sanctuaries of peace. Except for the more distant view of *Agnes Falls I*, the waterfalls are enclosed worlds without horizon. The waterfall is always the intense focus of the sanctuary, centralized on the canvas, the heart of the painting and landscape alike. Williams took particular delight in placing his waterfalls between contrasting elements of stone and vegetation. The painting of the falls themselves suggests a gendered landscape in which male and female principles are joined: the quicksilver spill of water and the all encompassing, dark wall of stone.

The Waterfall paintings remain amongst the most beautiful and mysterious of Williams' later landscapes. They mark a distinctive turning to a picturesque motif such as he had previously eschewed. Williams avoided the picturesque effect through the vigor and richness of his pictorial effects, never more apparent in a masterly group of rockfaces, which round out the series.

Years earlier when Williams was painting Sherbrooke Forest in the Dandenong Ranges just outside of Melbourne, he had brought the multifarious forms of the bush – tree trunks, branches, foliage and filtered light – into a wall-like surface where changes of texture conveyed brilliantly the fluctuating intricacies of the forest. In *Rockface at St Agnes Falls IV*, he used the same pictorial device. The surface of the canvas becomes the rockface. The fissures and the scrubby vegetation, the changing lights and colors of the rock, are freely worked right up on top of the surface with the texture of the paint, alternately rough and smooth, brilliantly rendering the variegated character of the rockface. A masterpiece of direct painting, Williams has happily transferred the freedom he found working directly before the motif to a studio picture of scale and intricacy.

In May and June of 1979, Fred Williams and his wife, Lyn, paid two visits to the Pilbara region in the northwest of Australia. Initially he went at the invitation of Sir Roderick Carnegie, then Chairman of Conzinc Rio-Tinto of Australia (CRA), which had extensive mining interests in the region. It was a landscape of unparalleled beauty, scale and spectacle and it was changing under the impact of large-scale mining operations. There was the vaguely expressed hope that Williams would record this changing landscape and that CRA would purchase the work. Williams would not accept a commission to paint a Pilbara series. If paintings emerged from his encounter with this landscape, then CRA could purchase a group. If they declined, he would simply keep the paintings himself. Astonishingly, nearly a hundred gouaches resulted from those two visits. But Williams was engaged in his Waterfall series, and he did not turn to the Pilbara project until March 1981, nearly two years after his initial visits.

Fred Williams loved the Pilbara from his first intense experience of it. It was his most extended exposure to outback Australia, the vast inland region of the island continent – wild, bare, deserted, minerally rich and spectacularly beautiful. He confided to his diary "anyone who could not paint this country is probably in the wrong profession." The idea of the series and the memory of the place grew and matured within his imagination. When he turned to the subject again in 1981, the series came with an ease and excitement. The Pilbara series was painted within six weeks from early March until mid-April. It would be his last series. CRA purchased 13 oil paintings and 18 gouaches from the group. In 2002, they presented them to the National Gallery of Victoria on the creation of a separate museum for Australian art, known as the Ian Potter Centre.

The Pilbara, with its brick red outcroppings and flat-topped mesas, its vast spaces and the spectacular changes of light and atmosphere over the course of a day, provided Williams with a range of subjects that could best (perhaps only) be apprehended in color. The fecundity of the gouaches from those initial visits, and the speed with which he painted the oil paintings, show how deeply he responded to the place and how comfortable he felt working in this landscape. For many painters, from Hans Heysen to Sidney Nolan, the outback has represented the Australian sublime: a landscape that inspires awe and wonder and a corresponding sense of desolation and fear. Aboriginal artists of the Center have no such fears, but for them too, the vast tracts of inland desert country is a place of primal experience, a land formed in the dawn of creation, in the Dreaming by their spirit ancestors.

Williams in the Pilbara put aside the grand rhetoric of earlier accounts by white artists. Instead he delighted in its variety of forms from its natural monuments to its most transient effects of changing light and color. He became particularly fond of painting the landscape at the end of the day with the first signs of cooling and the colors became even more resonant in easing light. The effect is brilliantly shown in the moonrise of *Shadow Under Red Cliff*. The heat retreats into the massif and makes it glow from within. Williams loved the geometry of the landscape, playing the scalloped forms of the desert plain against the base of the blocky, rectilinear cliff of ore and rock.

It was a landscape of effects as well as forms. *Morning Landscape (Pilbara Series)* answers back to the saturated hues and monumental forms of *Shadow Under Red Cliff*. Here the cool tones of first light spread across an extensive, featureless plain. It is like the dry bed of a great inward sea. Where the Pilbara is most easily characterized in terms of its ranges, its cliff faces, its mountains of iron ore, Williams makes boundlessness and emptiness the "genius of the place."

Although he did not revisit the Pilbara before embarking on the oil paintings in the [southern hemisphere] autumn of 1981, Williams never forgot the vividness of that first experience of flying over this vast red land. *Iron Ore Landscape* in the present exhibition is only explicable as the landscape seen from the air in a small plane, which banks and turns against the earth shifting the horizon into that dramatic angle, the earth slicing into the sky. The painting combines the drama of the landscape being discovered and explored and the obdurate mass of the ore rich earth below.

The Pilbara series had an extraordinary coda in a series of aerial views of West Australia of which *Coastline (A)* is one of the finest. These were the last pictures Williams would paint before he was diagnosed with inoperable lung cancer in November 1981. The painting derives immediately from the experience of flying south from the Pilbara to Perth down the coast of West Australia, where the scorching desert meets the Indian Ocean in the most elemental landscape drama of them all. Does the land form the sea or vice versa? The burning red-hot surface of the land pushes into the dense ultramarine as much as the push and pull of ocean tides shape the coastline.

Riverbed, another of these last works, represents the final distillation of the Gorge and Dry Creek Bed series. Splicing its way through the wide dry plain, the black line of the river is the shaping agent of the landscape. From the action of the small and seemingly insignificant comes the larger form of the landscape. Like *Coastline (A)*, it is the perpetual action of water on the vast dry land of Australia, which constitutes the final drama of the landscape. Fred Williams ended his career on an epic note.

Since his death more than 20 years ago, Williams' reputation has only grown in Australia. He has become a modern classic, and the enterprise of his art lies at the heart of the Australian story. Outside of Australia, his name and

achievement are known only in the most discerning and demanding circles. W. S. Liebermann went on to acquire a group of paintings for the Metropolitan and both the Tate Gallery and the British Museum, which held an extensive exhibition of his work in 2003, also acquired important works. These are harbingers, one feels, of a much wider acknowledgement of Williams' genius. Certainly, the story of 20th century landscape painting cannot be fully told without recognizing his substantial contribution. But that, I think, puts it too cautiously. The evolution of modern painting from 1960-80 cannot be properly understood without recognizing the power and originality of Fred Williams' art.

Patrick McCaughey has been the Director of three major art museums: the National Gallery of Victoria, Melbourne (1981-87); the Wadsworth Atheneum, Hartford, Connecticut (1988-96); The Yale Center for British Art, New Haven (1996-2001). He produced the first comprehensive monograph on Fred Williams in 1980, subsequently reprinted three times. In 2003, he published an Australian memoir, The Bright Shapes and the True Names *(Text, Melbourne). He lives and works as a writer in New Haven, Connecticut.*

FURTHER READING:

Fred Williams
 by Patrick McCaughey, Bay Books, Sydney, London, 1980; revised edition Murdoch Books, 1996

A Singular Vision, The Art of Fred Williams
 by James Mollison, Australian National Gallery & Oxford University Press, UK, 1989

Fred Williams: The Pilbara Series
 by Jennifer Phipps and Kirsty Grant, The National Gallery of Victoria, 2002

Fred Williams, An Australian Vision
 by Irena Zdanowicz and Stephen Coppel, The British Museum/Thames & Hudson Ltd., UK, 2003

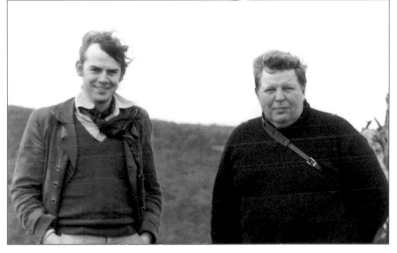

Patrick McCaughey and Fred Williams, 1978
Photographer: Lyn Williams © Lyn Williams, Fred Williams Estate/me

The Later Landscapes 1975 - 1981

Kew Billabong, Old Tyre II 1975 OIL ON CANVAS
42 X 36 1/4 INCHES
106.7 X 92 CENTIMETERS

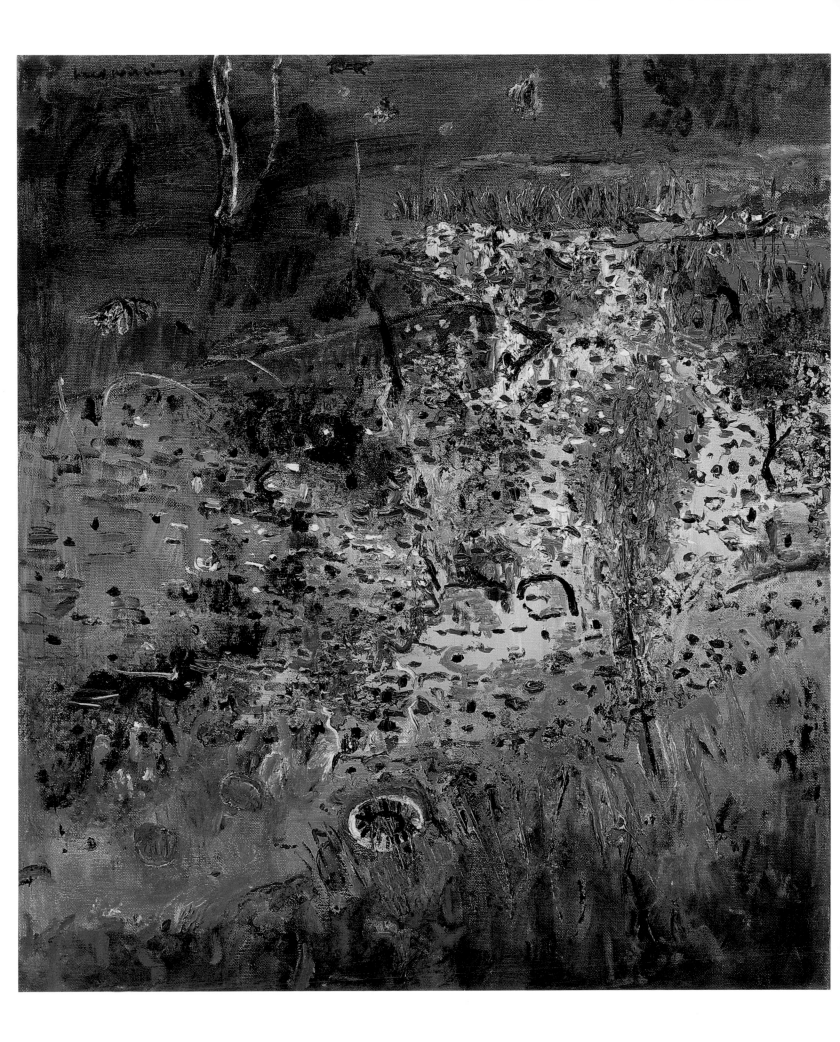

Dry Creek Bed
(Werribee Gorge Series)

1976 OIL ON CANVAS
48 X 48 1/8 INCHES
122 X 122.2 CENTIMETERS

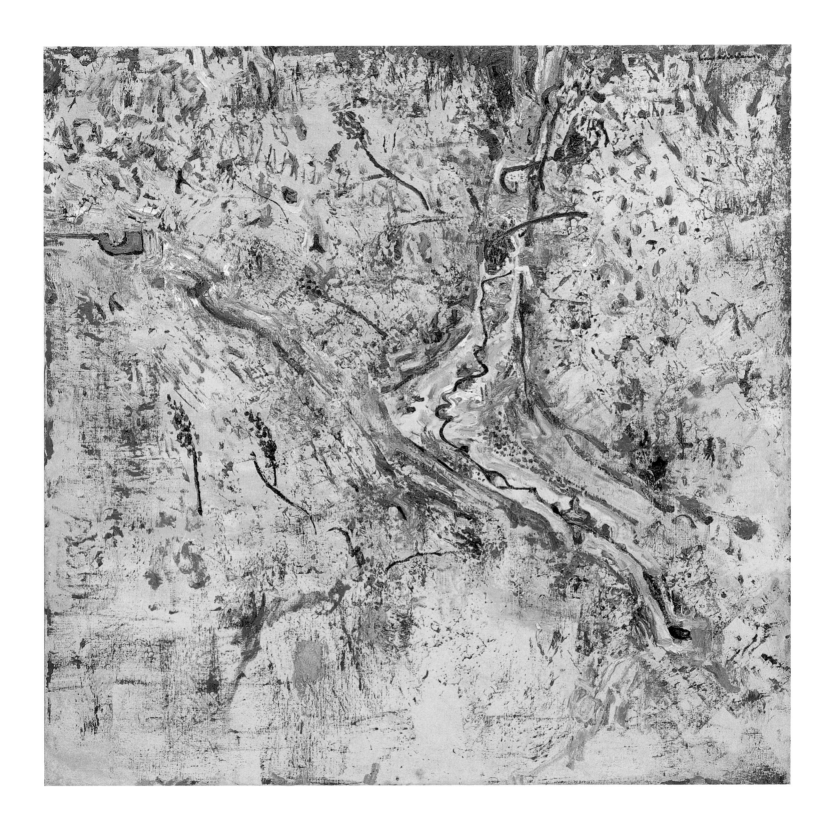

Golden Landscape 1975 OIL ON CANVAS
 40 X 40 INCHES
 101.7 X 101.7 CENTIMETERS

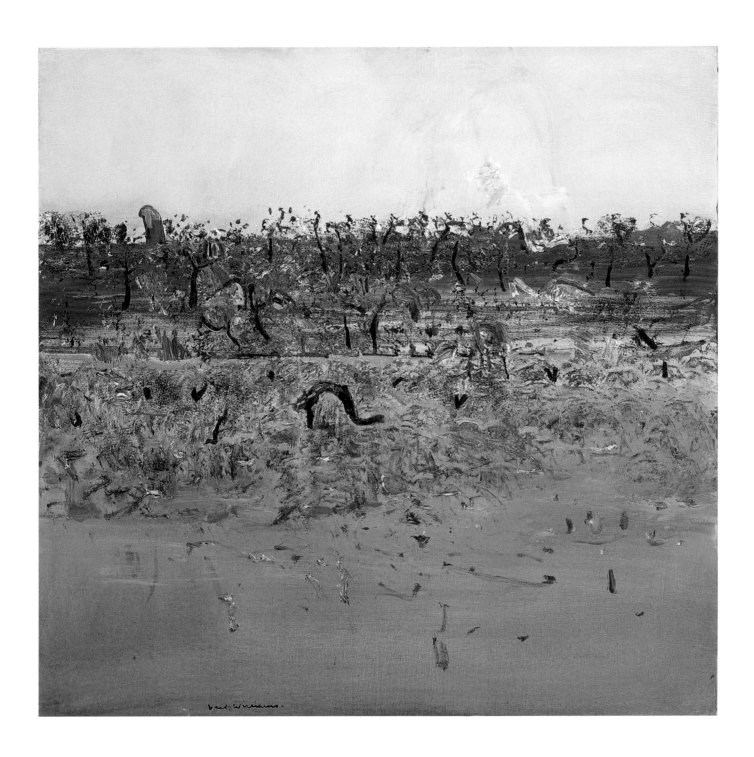

Silver Landscape

1975 OIL ON CANVAS

40 X 40 INCHES

101.7 X 101.7 CENTIMETERS

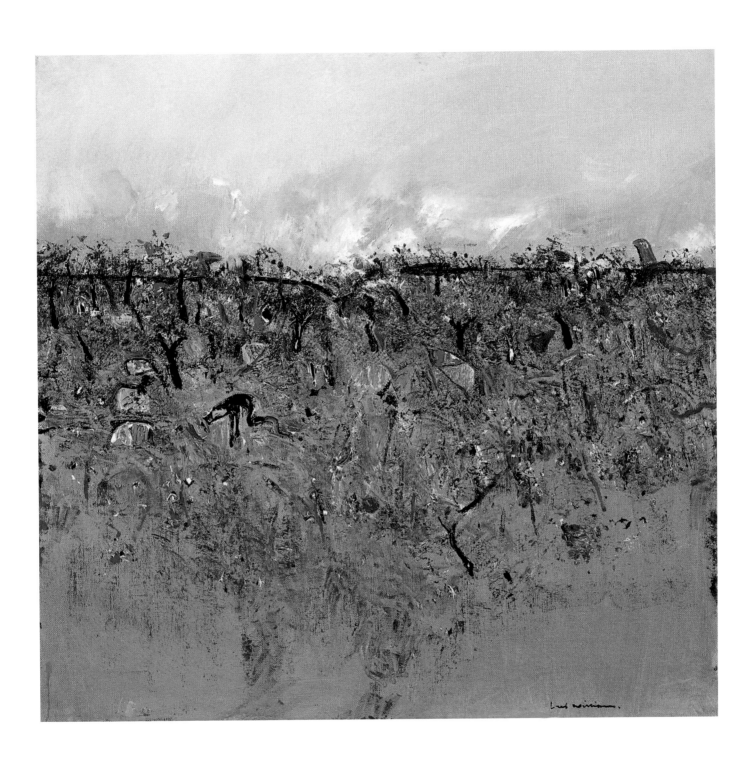

Rockface at Agnes Falls IV 1981 OIL ON CANVAS
72 X 60 INCHES
182.8 X 152.4 CENTIMETERS

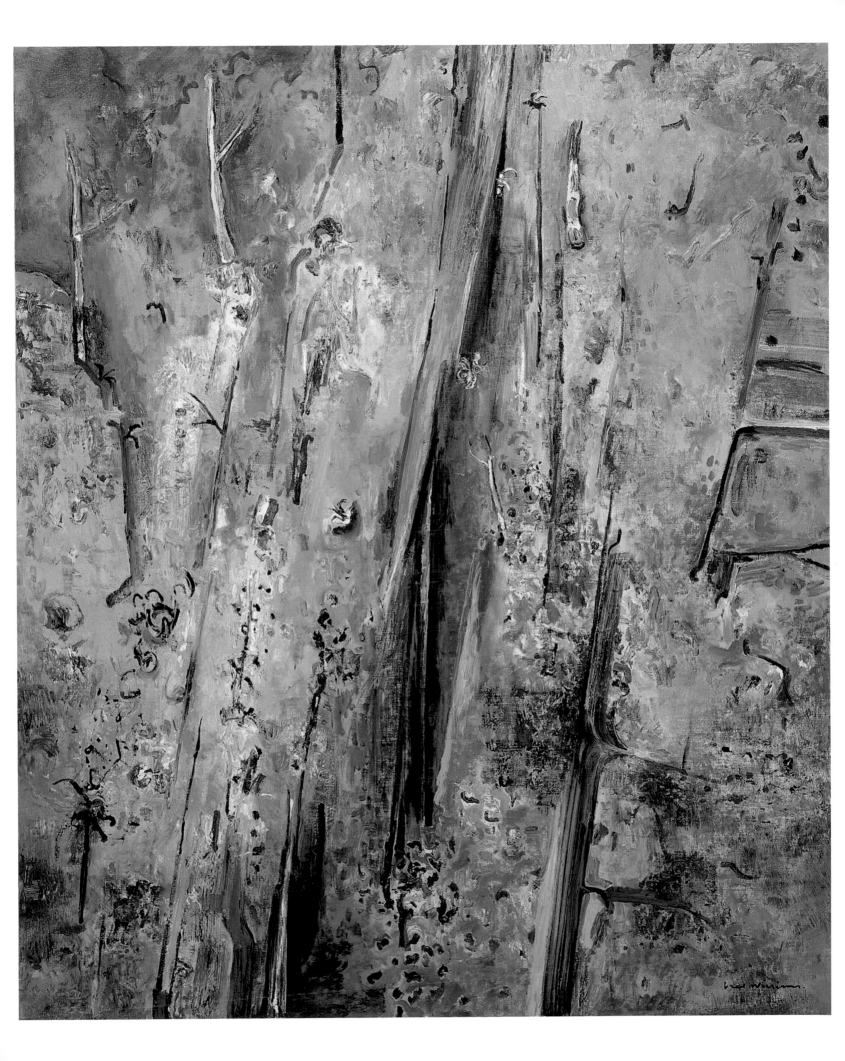

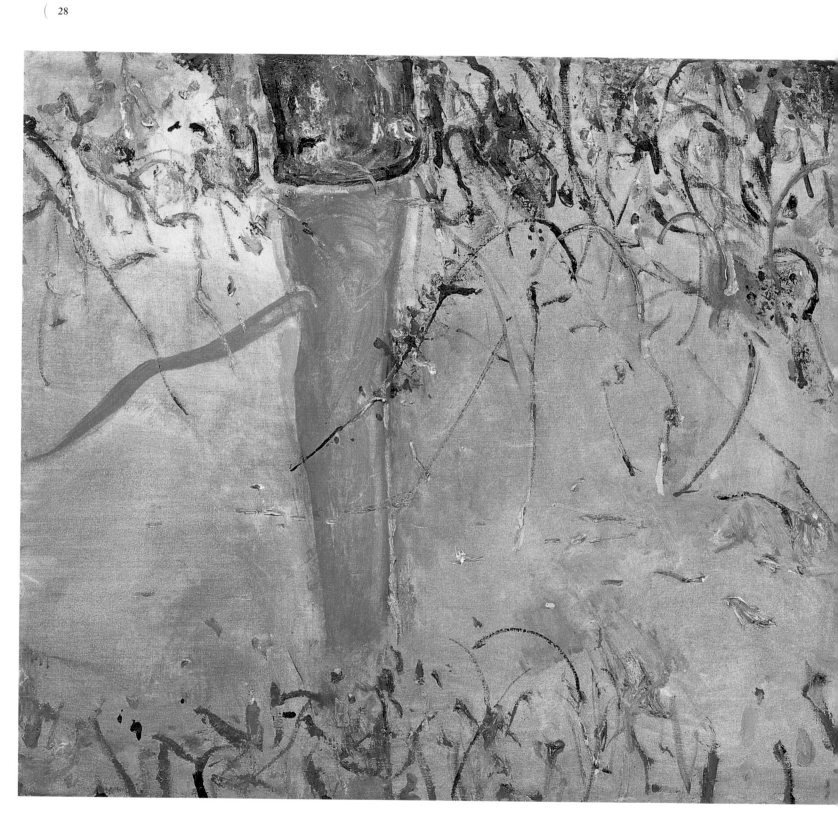

Reflected Tree Trunk
Kew Billabong, Diptych

1978 OIL ON CANVAS

337/8 X 753/4 INCHES

86.1 X 192.4 CENTIMETERS

OVERALL

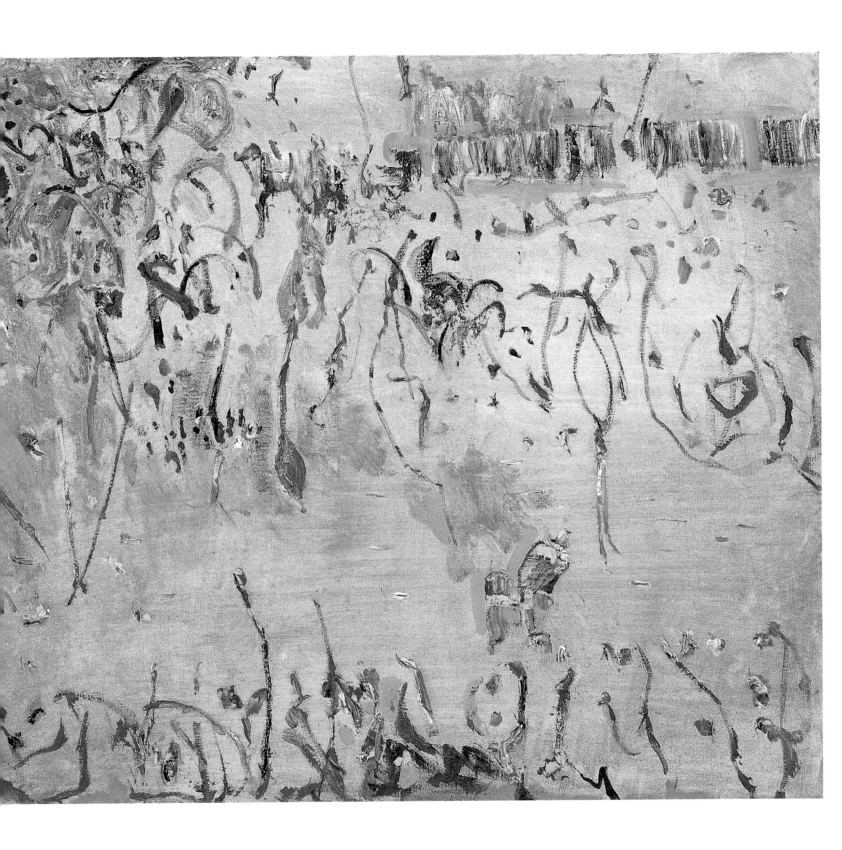

Strath Creek Falls III 1979 OIL ON CANVAS
42 X 377/8 INCHES
106.7 X 96.2 CENTIMETERS

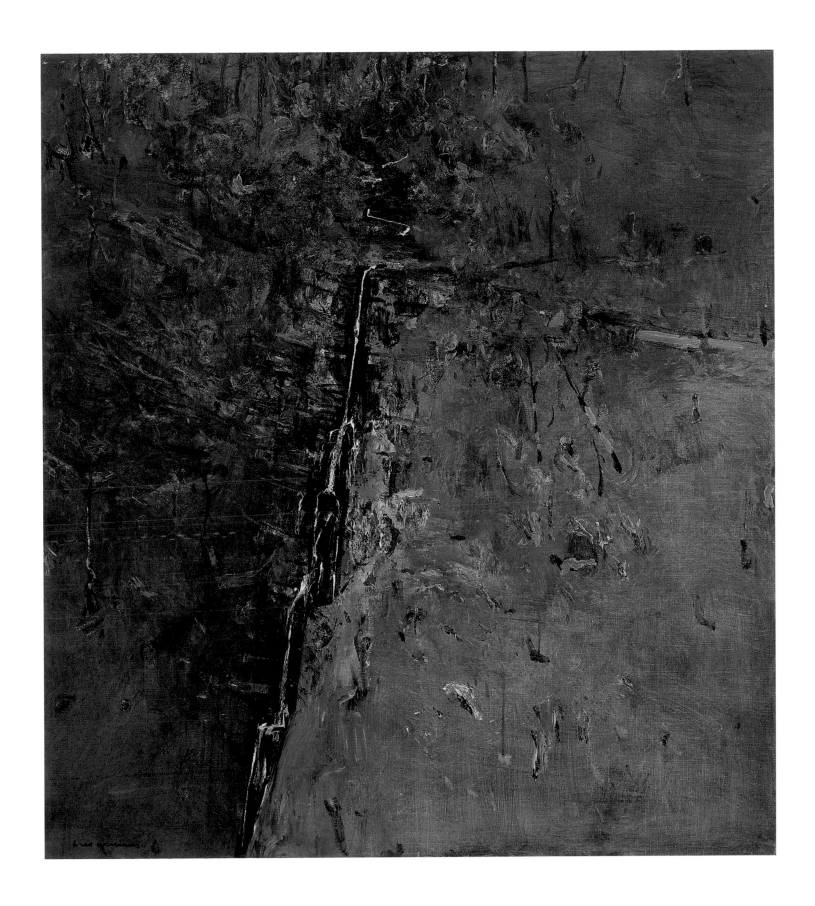

Agnes Falls I

1979 OIL ON CANVAS

41 7/8 X 37 7/8 INCHES

106.5 X 96.2 CENTIMETERS

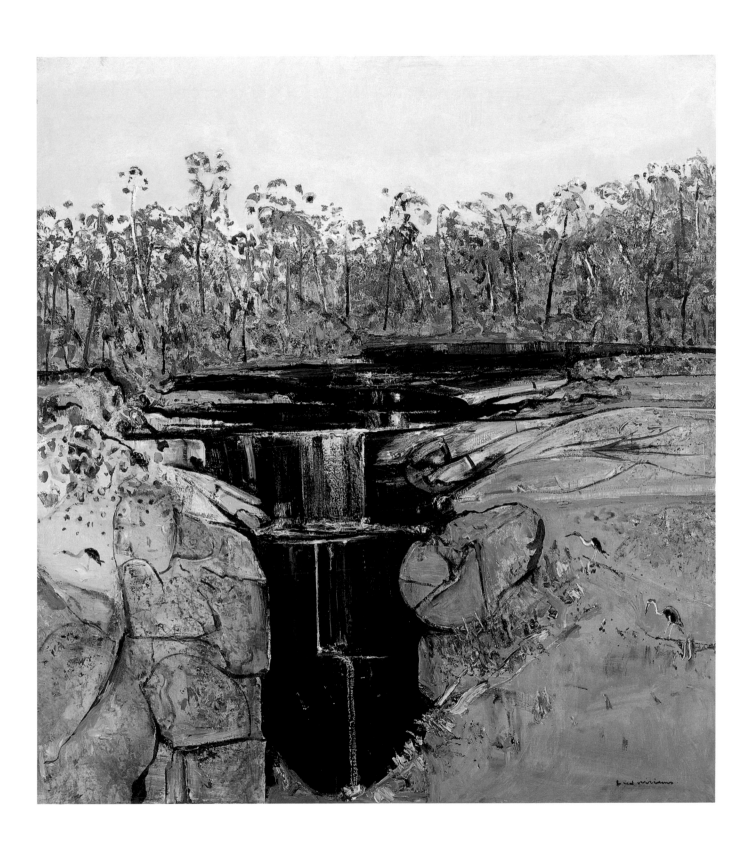

Coliban Falls I 1979 OIL ON CANVAS

42 X 377/8 INCHES

106.7 X 96.2 CENTIMETERS

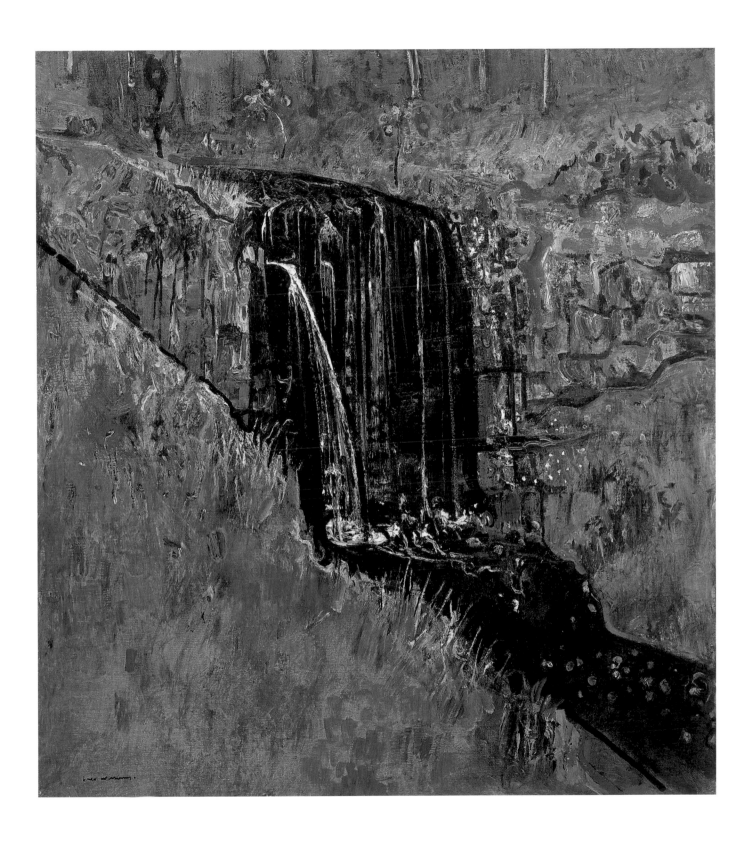

Pool at Agnes Falls II

1981 OIL ON CANVAS

597/8 X 72 INCHES

152 X 182.2 CENTIMETERS

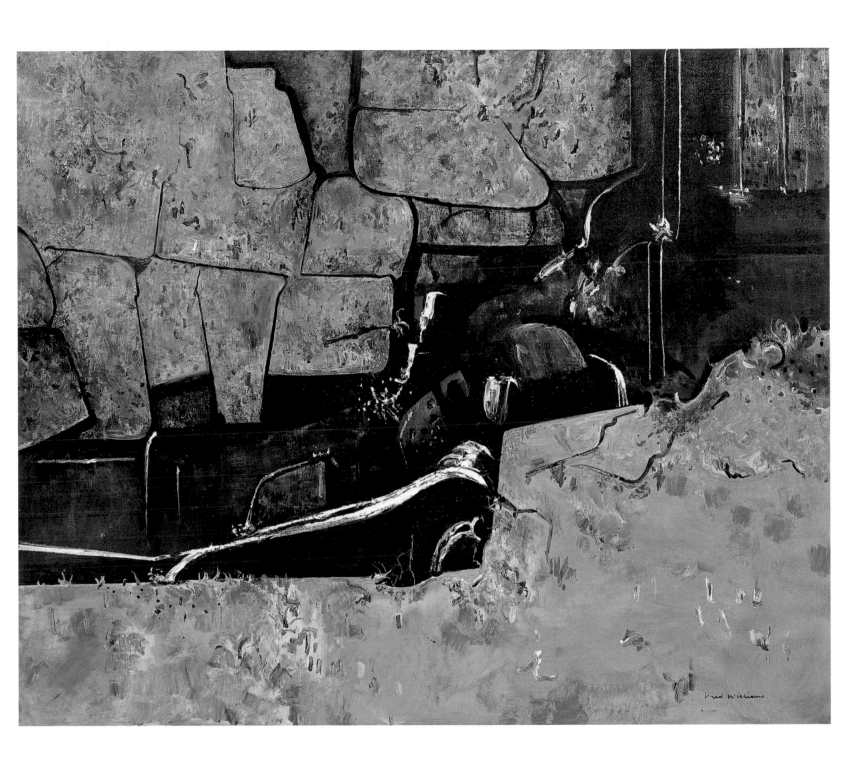

Morning Landscape 1981 OIL ON CANVAS
(Pilbara Series) 38 X 41 7/8 INCHES
 96.5 X 106.5 CENTIMETERS

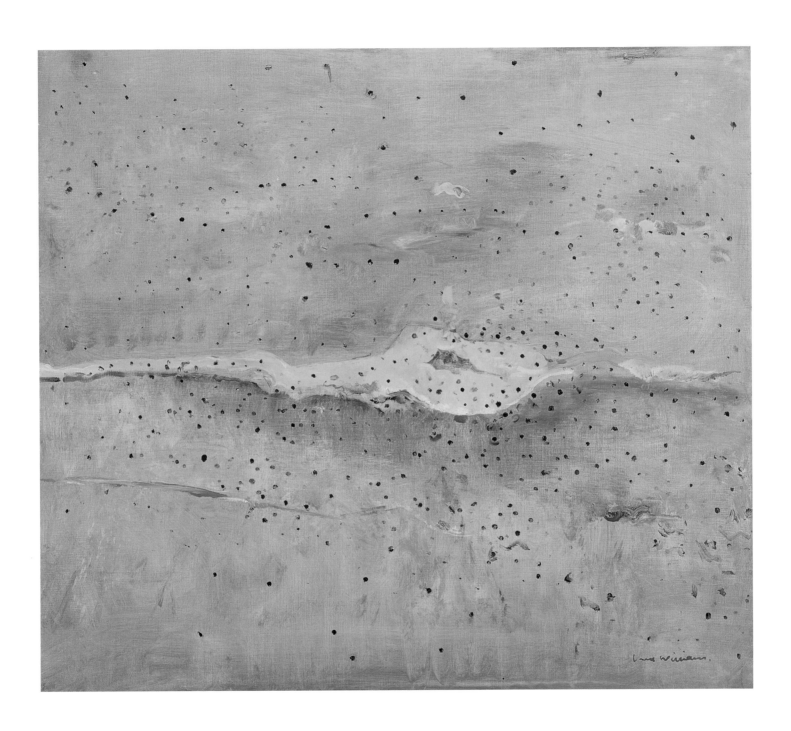

Lal Lal Falls III

1981 OIL ON CANVAS

71 7/8 X 60 INCHES

182.5 X 152.4 CENTIMETERS

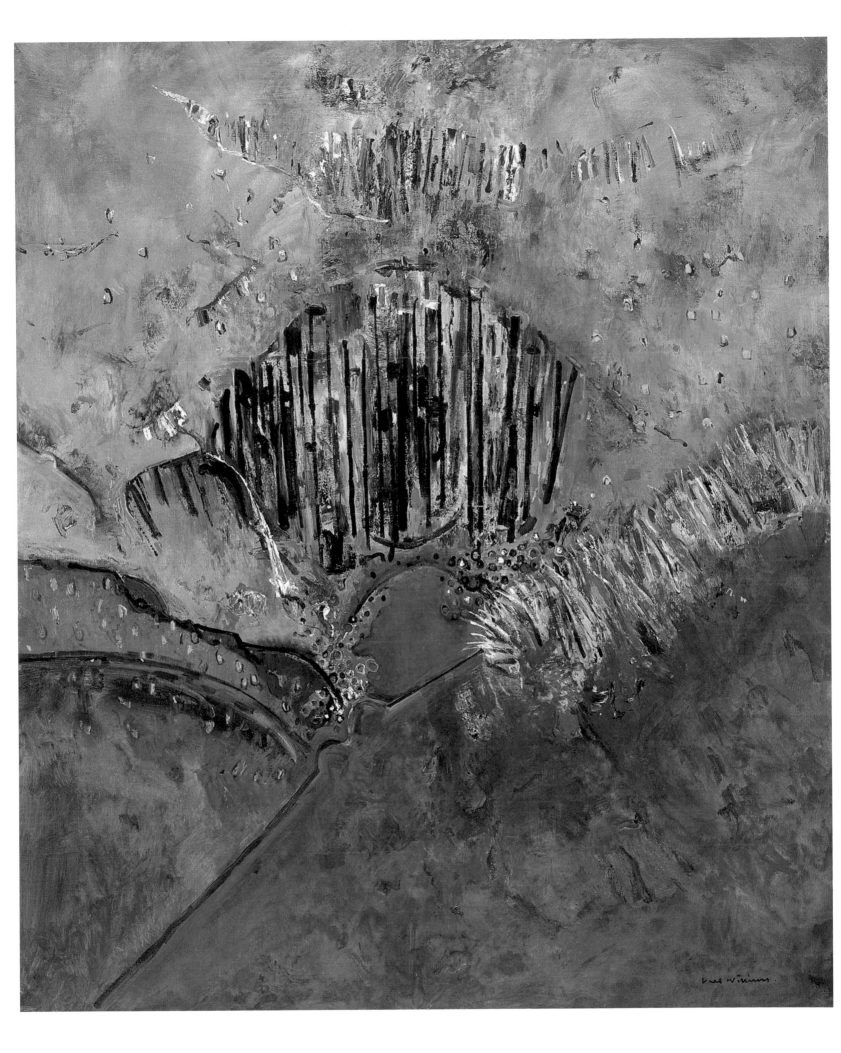

Shadow Under Red Cliff
(Pilbara Series)

1981 OIL ON CANVAS
48 X 47 7/8 INCHES
122 X 121.5 CENTIMETERS

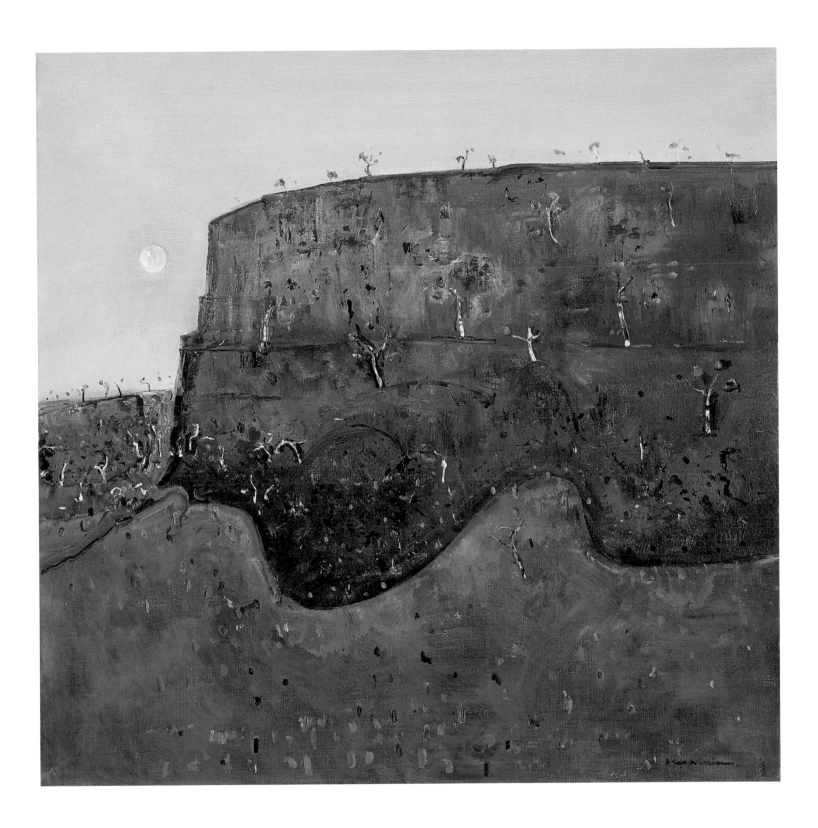

Iron Ore Landscape
(Pilbara Series)

1981 OIL ON CANVAS
37 7/8 X 42 INCHES
96.2 X 106.5 CENTIMETERS

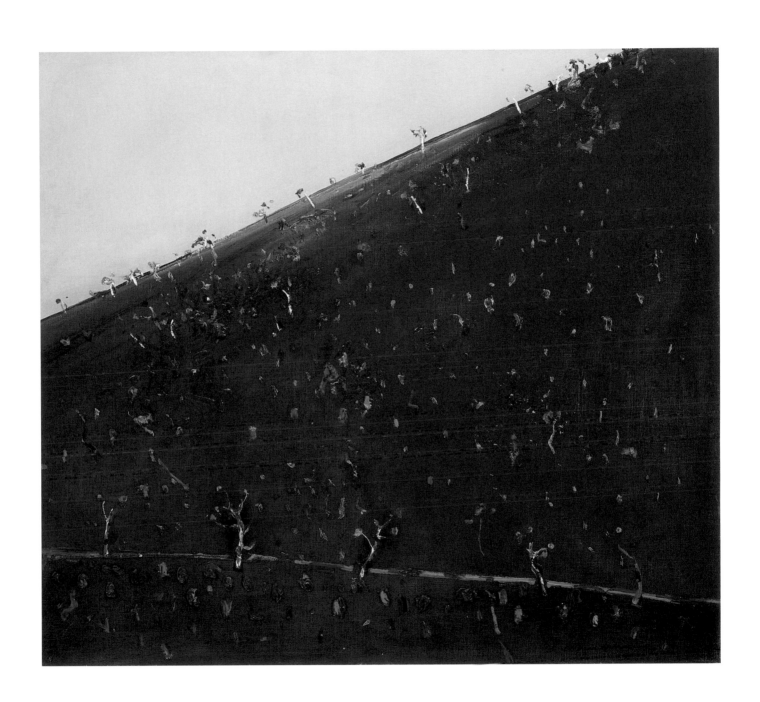

Lysterfield Paddock, Woodstacks 1977 OIL ON CANVAS
36 X 42 1/8 INCHES
91.5 X 107 CENTIMETERS

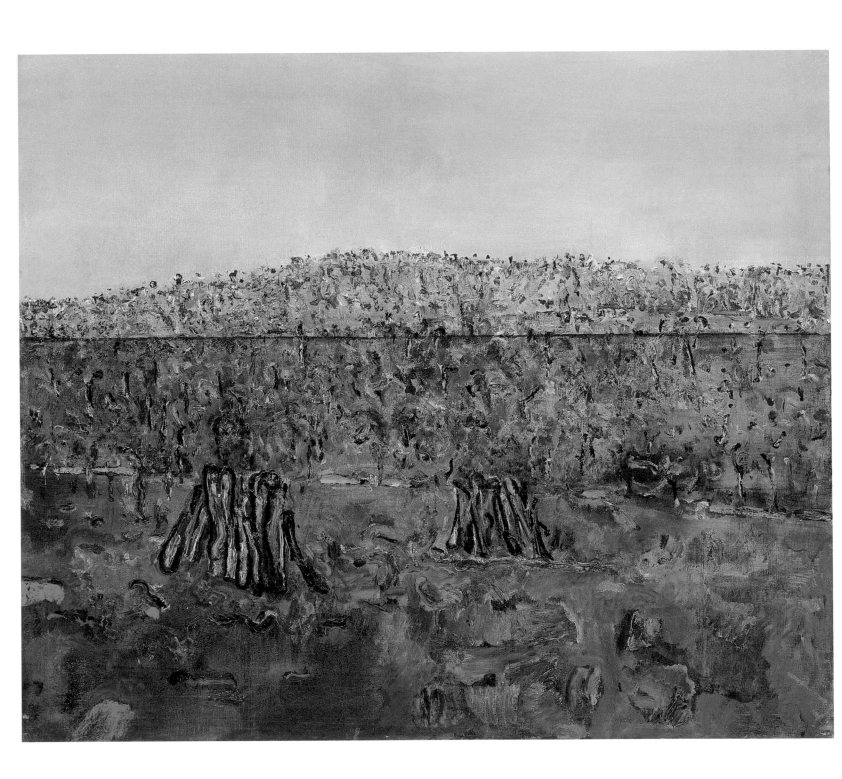

Coastline (A)

1981 OIL ON CANVAS

71 7/8 X 59 7/8 INCHES

182.5 X 152.1 CENTIMETERS

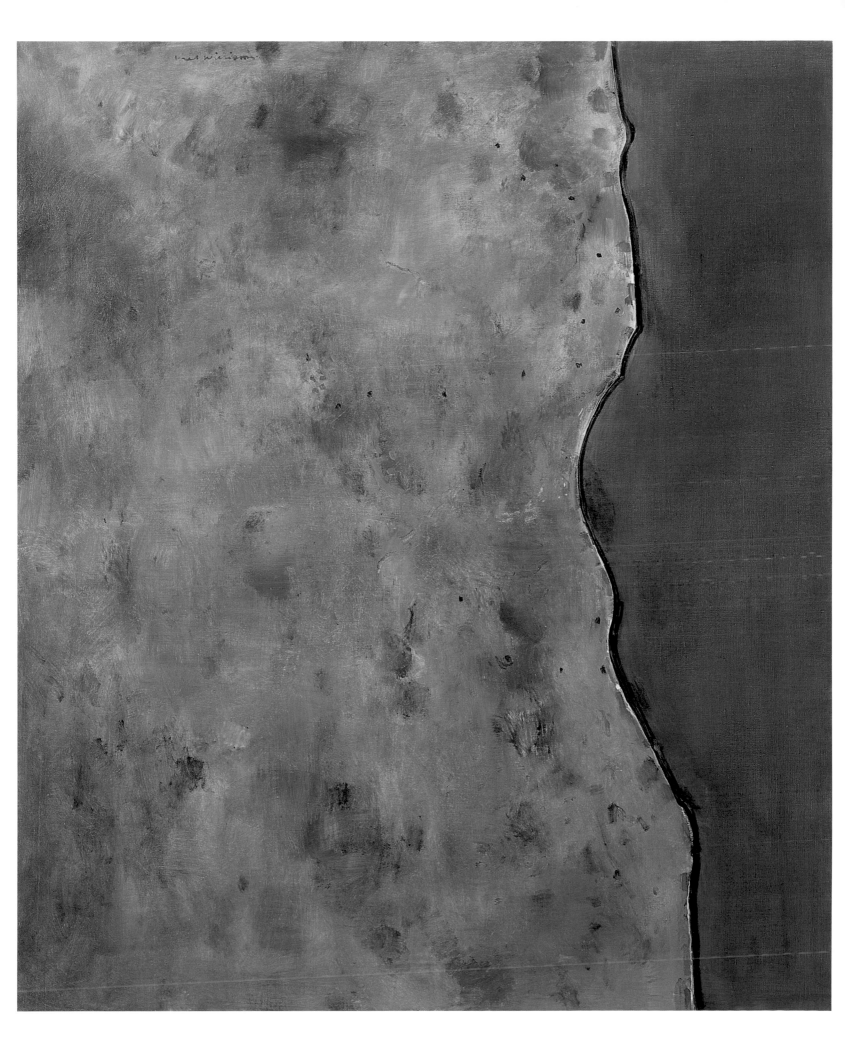

Riverbed (C)

1981 OIL ON CANVAS

71 7/8 X 59 7/8 INCHES

182.5 X 152.1 CENTIMETERS

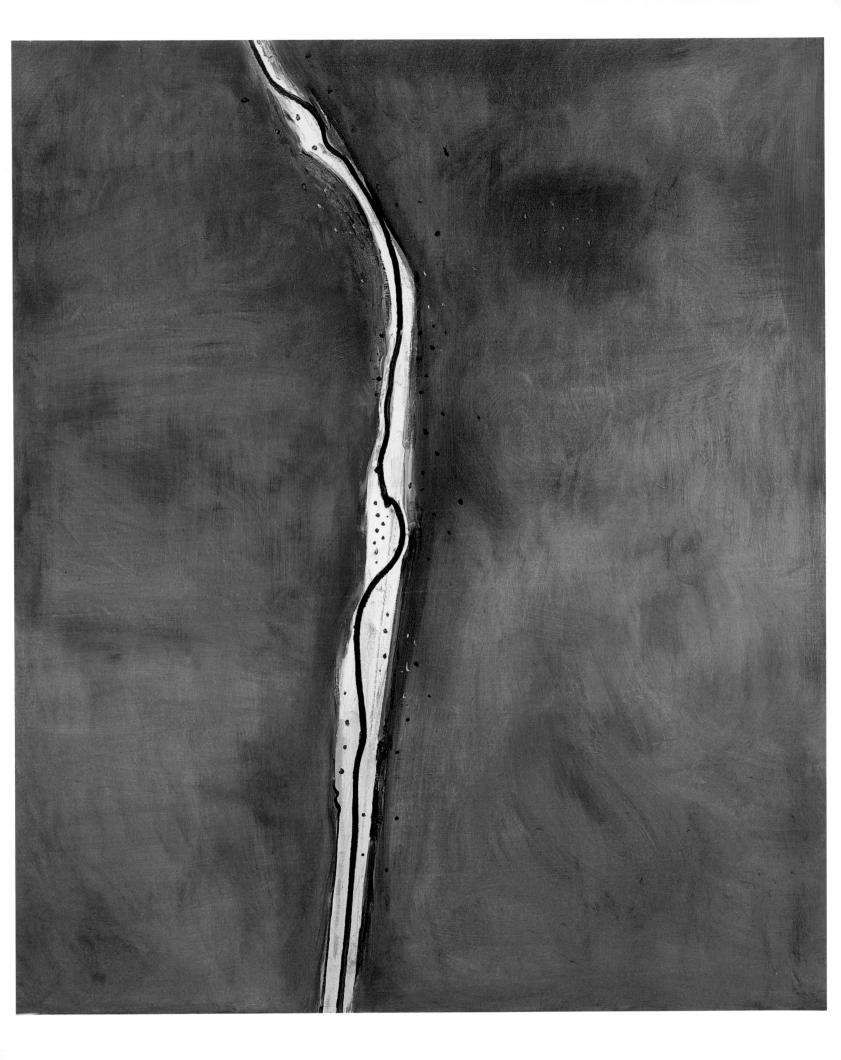

Biography Fred Williams 1927 - 1982

1927

Born in Melbourne.

1943 - 1950

Attended National Gallery School (1943-47) and the George Bell Art School (1946-50) in Melbourne.

1951 - 1956

Travelled to London, worked as a framer. Attended the Chelsea School of Art and Central Art School part-time. Learned etching technique, painted and etched Music Hall and London series.

1957

Returned to Australia. Landscape became the dominant theme in his work. Worked part-time as a picture framer.

1961

Married Lyn Watson.

1963

Moved from the city to Upwey, in the hills on the outskirts of Melbourne, the location becoming a major source of subject matter for his work.

1964

Travelled in Europe on the Helena Rubenstein Travelling Art Scholarship.

1969

Went to live in Hawthorn, Melbourne.

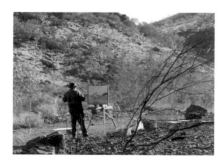

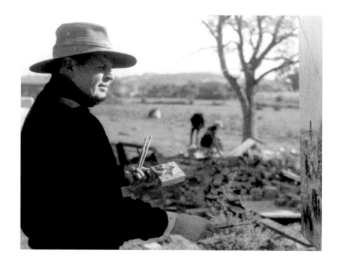

PHOTOS: LEFT TO RIGHT

Fred Williams at Cavan, Yass, New South Wales, 1977
Photographer: Lyn Williams © Lyn Williams, Fred Williams Estate/me

Fred Williams in the Pilbara, 1979
Photographer: Lyn Williams © Lyn Williams, Fred Williams Estate/me

Fred Williams at Yan Yean Swamp, 1972
Photographer: Anne Hall © Anne Hall, Fred Williams Estate/me

1972 - 1974

Member,
Commonwealth Art
Advisory Board.

1973 - 1976

Member, Visual Arts
Board of the Australia
Council.

1975 - 1982

Trustee, Council of the
National Gallery of
Australia, Canberra.

1976

Made Officer of the
Order of the British
Empire, (O.B.E).

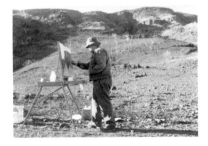

1980

Awarded Doctorate
Of Law, LL.D
(Honoris Causa) by
Monash University.

1982

Died April, Melbourne.

He is survived by
wife Lyn and three
daughters, Isobel,
Louise and Kate.

Fred Williams painting "Shadow Under Red Cliff" near Tom Price, Western Australia 1979
Photographer: Lyn Williams © Lyn Williams, Fred Williams Estate/me

Fred Williams in the garden, 1981
Photographer: Lyn Williams © Lyn Williams, Fred Williams Estate/me

Lyn and Fred Williams with children Kate, Isobel and Louise, 1973
Photographer: James Fitzpatrick © James Fitzpatrick, Fred Williams Estate/me

Selected Bibliography and Exhibitions

RECENT AUSTRALIAN PAINTING
WHITECHAPEL GALLERY, LONDON, UK, JUNE/JULY 1961

Australian Painting1788-1960
by Bernard Smith, Terry Smith and Christopher Heathcote, Oxford University Press, Melbourne, first ed. 1962, fourth ed. 2001

SOLO EXHIBITIONS WITH RUDY KOMON GALLERY
SYDNEY, 1962-1982

Australian Artists In The Tate
by John Reed, *The London Magazine*, pp. 62-65, February 1963

AUSTRALIAN PAINTERS, 1964-66
HAROLD E. MERTZ COLLECTION, CORCORAN GALLERY OF ART WASHINGTON, D.C., USA, 1967

A Grand Display of Australian Art in the U.S.
Life Magazine, USA, pp. 21-28, April 3, 1967

Fred Williams Etchings
by James Mollison, Rudy Komon, Sydney, 1968

Fred Williams, Etchings
by Earle Backen, *Art and Australia*, Vol. 6, No. 3, pp. 193-4, December 1968

National Gallery of Victoria
by Ursula Hoff and Margaret Plant, Cheshire, Melbourne, 1968

The Encyclopaedia of Australian Art
by Alan McCulloch and Susan McCulloch, Hutchinson, first ed. 1964; second ed. 1984; Allen & Unwin, third ed. 1994

Australian Prints
by James Mollison and Margaret McKean, Victoria and Albert Museum, London, UK, 1968

Masterpieces of Australian Painting
by James Gleeson, Lansdowne Press, Australia, 1969

A Guide to Modern Australian Painting
by R.K. Luck, Sun Books, Melbourne, 1969

The Art of Australia
by Robert Hughes, Penguin, Ringwood, revised ed. 1970

Modern Painters, 1931-1970
Lansdowne Press, Melbourne, 1971

AUSTRALIAN PRINTS
VICTORIA AND ALBERT MUSEUM, LONDON, UK, 1972

Fred Williams
by Patrick McCaughey, *Art International*, Vol. XVI, No. 9, November 1972

Inside Australia and New Zealand
by John Gunther, Hamish Hamilton, London, UK, 1972

Landscapes Fascinate Chinese
by Daniel Thomas, *Sydney Morning Herald*, September 11, 1975

The Most Noble Art of them All
by Laurie Thomas, University of Queensland Press, Brisbane, 1976

University Art Museum, John Darnell Collection
University of Queensland Press, Brisbane, 1976

Visual Images in Man and Landscape in Australia
by G. Seddon & M. Davis, Australian Government Publishing Service, Canberra, 1976

FRED WILLIAMS: LANDSCAPE OF A CONTINENT
CURATED BY WILLIAM S. LIEBERMAN MUSEUM OF MODERN ART, NEW YORK, USA, MARCH – MAY 1977 TRAVELED TO NORTON GALLERY, WEST PALM BEACH, FLORIDA, USA, 1977 JOSLYN ART GALLERY, OMAHA, NEBRASKA, USA, 1978 UNIVERSITY OF TEXAS ART MUSEUM, AUSTIN, TEXAS, USA, 1979

Art: Six Greats at Morgan Library
by John Russell, *New York Times*, U.S.A., March 8, 1977

Museum of Modern Art
by Thomas B. Hess, New York, USA, April 4, 1977

Fred Williams
by William S. Lieberman, *Australia Newsletter*, Sydney Morrell and Co., New York, p. 9, 1977

Studies in Australian Art
ed.s Ann Galbally and Margaret Plant, University of Melbourne, 1978

Aspects of Finish
by Margaret Plant, Quattrocento, Melbourne, Melbourne University, pp. 101-104, 1978

The Limits of Vision
by Patrick McCaughey, The Sir William Dobell Foundation, 1978

Fred Williams,
Abstracted Landscapes
by Alwynne Mackie, *Art and*
Australia, Vol. 16, No. 3, March 1979

Fred Williams, New Visions
in Landscape...
by Alwynne Mackie, *Art International*,
Vol. XXIII, No. 5-6, September 1979

FRED WILLIAMS,
OEUVRES 1969-79
AUSTRALIAN EMBASSY, PARIS,
FRANCE, APRIL/MAY 1980

FRED WILLIAMS,
LANDSCAPES 1969-79
FISCHER FINE ART, LONDON, UK,
MAY/JUNE 1980

Fred Williams, An Australian
by Louise Collins, *Art and Artists*,
p. 31, July 1980

Exploring Fred Williams
by Anthony Clarke, *The Age Weekend*
Review, Melbourne, July 12, 1980

FRED WILLIAMS, WORKS
IN THE NATIONAL GALLERY
OF VICTORIA, PAINTINGS,
GOUACHES AND PRINTS
NATIONAL GALLERY OF VICTORIA,
MELBOURNE, OCTOBER/
NOVEMBER 1980

Fred Williams, The Sources...
by Maria Prerauer, *The Weekend*
Australian Magazine, Sydney, p.15,
October 18-19, 1980

Fred Williams
by Patrick McCaughey, Bay Books,
Sydney, London, 1980; revised edition
Murdoch Books, 1996

Fred Williams, Works in the
National Gallery of Victoria
by Robert Lindsay and Irena
Zdanowicz, National Gallery of
Victoria, Melbourne, 1980

The George Bell School, Students,
Friends and Influences
by Mary Eagle and Jan Minchin,
Deutscher Art Publications,
Melbourne, Resolution Press,
Sydney, 1981

The Artist and the Desert
by Sandra McGrath and John Olsen,
Bay Books, Sydney, pp. 110-119, 187;
1981

He Changed the Way We See
Our Country
Transcript of eulogy given by John
Brack, *The Weekend Australian*,
Sydney, p. 14, April 24-25, 1982

Tribute
by Barry Jones, House of
Representatives, Australian Parliament,
Hansard, p. 1919, April 27, 1982

Fred Williams
by Michael Davie, *The Age Monthly*
Review, Melbourne, May 3, 1982

Tribute to Fred Williams
by Prof. Margaret Plant, *Art Bulletin of*
Victoria, No. 23, pp. 62-64, May 1982

Fred Williams, Australian
Landscape Painter
Obituary, *The Times*, London, UK,
May 15, 1982

Fred Williams, Appreciation
by John Brack, *Art and Australia*,
Vol. 20, No. 2, p. 198, June 1, 1982

Australian Art
by Bryan Robertson, *The Spectator*,
London, UK, May 29, 1982

Fred Williams Redemption
by Peter Fuller, *The Age Monthly*
Review, Melbourne, p. 5, March, 1983

Williams and Robert Klippel
by James Gleeson, Art Gallery of
New South Wales, Sydney, May 1983

FRED WILLIAMS: THE
PILBARA SERIES, 1979-81
ART GALLERY OF WESTERN
AUSTRALIA, AUGUST/SEPTEMBER
1983
TRAVELED TO ART GALLERY OF
SOUTH, AUSTRALIA, SEPTEMBER –
NOVEMBER 1983
NATIONAL GALLERY OF VICTORIA,
NOVEMBER 1983 – JANUARY
1984
ART GALLERY OF NEW SOUTH
WALES, FEBRUARY/MARCH 1984
QUEENSLAND ART GALLERY,
APRIL/MAY 1984
NATIONAL GALLERY OF AUSTRALIA,
APRIL – JUNE 1985

Fred Williams: The Pilbara Series,
1979-1981
by Patrick McCaughey, CRA Limited,
1983

Pilbara Statement is Williams
at His Best
by Sandra McGrath, *The Weekend*
Australian Magazine, Sydney, p. 12,
August 6-7, 1983

The Iron Landscape
by Memory Holloway, *The Age*,
Melbourne, p.15, November 26, 1983

Fred Williams, Visions of Australia
by R. Lindsay, *Apollo*, UK, No. 262,
Vol. 118, December 1983

Australia
by J. F. Walker, *Artscribe*, UK, No. 44,
pp. 33-38, December, 1983

Australian Art Review 2
ed. Leon Paroissien, Warner Associates
with Oxford University Press,
Melbourne and UK, 1983

Fred Williams and the Pilbara Series
by Patrick McCaughey,
Studio International, UK,
pp. 30-31, 197, 1005; 1984

The Australian Landscape
by Peter Fuller, *New Society*,
pp. 387-388, June 7, 1984

FRED WILLIAMS, GOUACHES
AUSTRALIAN NATIONAL GALLERY,
CANBERRA, ACT, AUGUST –
OCTOBER 1984

*Fred Williams, Gouaches, Australian
Naional Gallery*
Handbook, Australian National Gallery,
Canberra, A.C.T., 1984

**A JOURNEY THROUGH
CONTEMPORARY ART**
CURATED BY NIGEL GREENWOOD
THE HAYWARD ANNUAL, HAYWARD
GALLERY, LONDON, UK,
MAY – JULY 1985

The Hayward Annual
by Peter Fuller, *Modern Painter*,
July/August, 1985

More Than Just So
by Michael Spens, *Studio International*,
UK, Vol. 198, No. 1009, p. 50-51; 1985

**FRED WILLIAMS: THE PILBARA
SERIES, 1979-81**
TRAVELED TO VENUES IN BEIJING,
PEOPLE'S REPUBLIC OF CHINA,
AUGUST 1985
SHANGHAI, PEOPLE'S REPUBLIC OF
CHINA, AUGUST/SEPTEMBER 1985
SEOUL, KOREA, SEPTEMBER 1985
TOKYO, JAPAN, OCTOBER/NOVEMBER
1985

*20th Century Masterpieces from the
Art Gallery of New South Wales,
and Fred Williams' Pilbara Series,
CRA Collection*
Foreword by Patrick McCaughey,
Tokyo Metropolitan Teien Art Museum,
Japan, 1985

Diversity Itself
ed. Peter Quartermaine, pp. 151-152, 157,
University of Exeter, UK, 1986

**LEGENDS AND LANDSCAPE IN
AUSTRALIAN ART, FROM THE
HAROLD MERTZ COLLECTION**
SARAH CAMPBELL BLAFFER GALLERY,
UNIVERSITY OF HOUSTON, TEXAS,
USA, NOVEMBER/DECEMBER 1986

*Legends and Landscapes in Australian
Art - From the Mertz Collection*
Essay by Robert Hughes, University
of Texas, USA, 1986

Red Cliff landscape
Art in America, USA, Vol. 74, p. 29,
January 1986

**SOLO EXHIBITIONS
WITH REX IRWIN**
SYDNEY, 1987-2000

Pilbara's Progress, Fred Williams
by Janet McKenzie, *Studio International*,
UK, Vol. 199, No. 1015, p. 37,
December 1986 – February 1987

**FRED WILLIAMS:
A RETROSPECTIVE**
AUSTRALIAN NATIONAL GALLERY,
CANBERRA, OCTOBER 1987 –
JANUARY 1988
TRAVELED TO NATIONAL GALLERY
OF VICTORIA, MELBOURNE,
FEBRUARY – APRIL 1988
TASMANIAN MUSEUM AND ART
GALLERY, HOBART, APRIL/MAY
1988
ART GALLERY OF WESTERN
AUSTRALIA, PERTH, JUNE/JULY
1988
ART GALLERY OF SOUTH AUSTRALIA,
ADELAIDE, AUGUST – OCTOBER
1988
QUEENSLAND ART GALLERY,
BRISBANE, NOVEMBER 1988 –
JANUARY 1989
ART GALLERY OF NEW SOUTH
WALES, SYDNEY, FEBRUARY –
APRIL 1989
MUSEUM AND GALLERY VENUES,
NORTHERN TERRITORY,
APRIL – JUNE 1989

*Through Antipodean Eyes, The Vivid
Imagery of Australia's Artists*
by Peter Fuller, *Architectural Digest*,
USA, Vol. 44, p. 204+, September 1987

Fred Williams, A Major Exhibition
by Annabel Davie, *Art Monthly*, UK,
pp. 4-7, November 1987

*Fred Williams, Portfolio of
12 Reproductions*
selection and notes by Terence Measham
and Felicity Moore, Australian National
Gallery, Canberra, 1987

*Fred Williams: A souvenir book of
the artist's work in the Australian
National Gallery*
by James Mollison, Australian
National Gallery, Canberra, 1987

Fred Williams
by Peter Fuller, *The Burlington
Magazine*, London, UK, Vol. 130,
p. 49-50, January 1988

**FRED WILLIAMS: THE
PILBARA SERIES, 1979-81**
SERPENTINE GALLERY, LONDON,
UK, JANUARY/FEBRUARY 1988
TRAVELED TO ULSTER MUSEUM,
BELFAST, IRELAND, MAY/JUNE
1988
BUTLER GALLERY, KILKENNY,
IRELAND, AUGUST/SEPTEMBER
1988

*Topography, Fred Williams and
the Young Turner*
by William Feaver, *The Observer*,
London, UK, p. 23, January 31, 1988

Pictures In the Mind's Eye
by Marina Vaizey, *Sunday Times*,
London, UK, January 31, 1988

*Landscapes Seen Through
Abstract Eyes*
by William Packer, *The Financial Times*,
London, UK, February 4, 1988

Essential Australia
 by Giles Auty, *The Spectator*, London,
 UK, p. 33, February 6, 1988

Fred Williams, Serpentine Gallery
 by Mary Rose Beaumont,
 Arts Review, London, UK,
 Vol. 1, pp. 83-84, February 12, 1988

*That Is How A Landscape
Should Be...*
 by Ian Burn, *Australian and
 International Art Monthly*,
 Issue 8, pp. 1-2, March 1988

The Pilbara Series
 by Peter Fuller, *Australian and
 International Art Monthly*,
 Issue 8, pp. 3-4, March 1988

*Fred Williams: Gorge Landscape
Studio International*, Vol. 201,
 p. 68, April 1988

Fred Williams
 by Bernard Smith, *Modern Painters*,
 London, UK, Vol. 1, No. 1, pp. 69-72,
 Spring 1988

*The Art of Fred Williams, Visionary
In Conflict, The Great Australians*
 by Bernard Smith, *The Weekend
 Australian Magazine*, Sydney, p. 6,
 May 7-8, 1988

*Fred Williams, Ulster Museum,
Belfast*
 by Elaine Hogg, *Circa Art Magazine*,
 Belfast, Ireland, No. 41, pp. 32-33,
 August/September 1988

*A Singular Vision,
The Art of Fred Williams*
 by James Mollison, Australian
 National Gallery & Oxford
 University Press, UK, 1989

*Selected Affinities, Fred Williams'
Drawings After Rembrandt*
 by Irena Zdanowicz, *Art Bulletin of
 Victoria*, National Gallery of Victoria,
 No. 29, pp. 24-37 illus., 1989

Images of God
 by Peter Fuller, The Hogarth Press,
 London, Ch. 23 Fred Williams,
 pp. 176-183; 1990

*Two Hundred Years of
Australian Painting*
 Australia - Japan Foundation,
 Museums of Modern and Western Art,
 Tokyo, Kyoto, Japan, 1992

*The Reserve Bank of
Australia Collection*
 by Lou Klepac, The Reserve Bank
 of Australia, August 1992

The Obscure Poetics of Fred Williams
 by Dr. John Lechte, *Architecture,
 Space, Painting, Journal of Philosophy
 and the Visual Arts*, pp. 82-89; 1993

*Fred Williams,
Landscape With Rocks I*
 by Sabine Rewald, *Metropolitan
 Museum of Art Bulletin*, p. 69,
 Fall 1993

**SOLO EXHIBITIONS WITH
PHILIP BACON GALLERIES**
BRISBANE, 1994-2004

*The Triumph of The New: The
Ascendency of Australian Art 1946-68*
 by Dr. Christopher Heathcote,
 Text Media, 1995

*Australian Watercolours: Selected
Works From the Collection*
 Art Gallery of New South Wales,
 Sydney, 1995

FRED WILLIAMS, 1927-1982
MARLBOROUGH FINE ART, LONDON,
UK, NOVEMBER/DECEMBER 1995

Fred Williams (1927-1982)
 by John McDonald, Marlborough
 Fine Art, London, August 1995

**FRED WILLIAMS:
A WORKING METHOD**
NATIONAL GALLERY OF VICTORIA,
MELBOURNE, DECEMBER 1995 –
FEBRUARY 1996

Fred Williams: A Working Method
 by James Mollison and Kirsty Grant,
 National Gallery of Victoria, Melbourne,
 1995

Gathering Paint
 by Simon Plant, *Weekend Herald Sun*,
 Melbourne, p. 7, December 16, 1995

*Fred Williams and the Path
To Perfection*
 by Jason Steger, *The Sunday Age*,
 Agenda, Melbourne, p. 7,
 December 17, 1995

Lay It On Thick
 by Jeff Makin, *The Herald Sun*,
 Melbourne, p. 33, January 6, 1996

*Williams Shows What's
Around the Corner*
 by Robert Nelson, *The Age*, Melbourne,
 p. 12, January 10, 1996

Dictionary of Art
 ed. Jane Shoaf Turner, McMillans,
 London, 1996

**FRED WILLIAMS:
THE QUEENSLAND GOUACHES**
TRAVELED TO GOLD COAST CITY
ART GALLERY, CAIRNS REGIONAL
GALLERY, GLADSTONE REGIONAL
ART GALLERY AND MUSEUM,
ROCKHAMPTON CITY ART
GALLERY, PERC TUCKER REGIONAL
GALLERY, TOWNSVILLE,
MAY – DECEMBER 1996

*Fred Williams:
The Queensland Gouaches*
 curated and catalogue essay by
 Scott J. Brown, Gold Coast City Art
 Gallery, Gold Coast, Queensland, 1996

Intense Visions of Our Landscape
by Sasha Grishin, *The Canberra Times*,
p. 17, January 30, 1996

Best of It
The Financial Review, Weekend,
Australia, p. 14, February 2, 1996

The Real Thing
essay by Margaret Plant, "Render Unto
the Gum Tree," Museum of Modern
Art at Heide, 1997

The Modern Landscape 1940 – 1965
Museum of Modern Art at Heide, 1998

Fred Williams' Pilbara:
Images From The North West
by Anne Gray, University of Western
Australia, 1998

Fred Williams "In Queensland"
1971 – 1978
Philip Bacon Galleries, 1998

Fred Williams (1927 – 1982)
Landscapes
Rex Irwin Art Dealer, 1998

The Artists' Retreat: Discovering
The Mornington Peninsula 1850s
To The Present
Mornington Peninsula Regional Gallery,
1999

Fred Williams: Drawing The Exotic
Museum of Modern Art at Heide, 1999

Fred Williams –
The Bluff, Mornington 1968
Friends of the Mornington Peninsula
Regional Gallery Newsletter,
October/November 1999

Natural Disasters/Disasters Unnatural
Monash University Gallery,
May - July 1999

An Interview With Gerard Vaughan
Maria Prendergast, *GALLERY*
Members Magazine of the National
Gallery, Society of the National
Gallery of Victoria, Melbourne,
October/November 1999

Landscapes In Sets and Series
Australian Prints 1960s –1990s
National Gallery of Australia,
Canberra, July – November 1999

Fred Williams
Etchings associated with River Murray
Scenes, Adelaide Festival Centre,
December 1999 – February 2000.

An Artist's Homage
Barry Pearce spoke to Judith White,
LOOK Art Gallery of New South
Wales, Sydney, February 2000

From Appreciation to Appropriation
Flinders University Art Museum,
Adelaide, March/April 2000

MODERN AUSTRALIAN
LANDSCAPE PAINTING:
BOYD, DRYSDALE, NOLAN,
PERCEVEL, WILLIAMS
NATIONAL GALLERY OF VICTORIA,
MELBOURNE, 2000

Modern Australian Landscape
Painting: Boyd, Drysdale, Nolan,
Percevel, Williams
National Gallery of Victoria,
Melbourne, 2000

Modern Australian Landscape
Painting: Boyd, Drysdale, Nolan,
Percevel, Williams
by Geoffrey Smith, *GALLERY*
Members Magazine of the National
Gallery, Society of the National Gallery
of Victoria, April/May 2000

Fred Williams - Paintings, 1959-1978
Philip Bacon Galleries, Brisbane,
April/May 2000

Fred Williams (1927-1982) Major
Paints and Etchings From the Estate
of the Artist
Rex Irwin Art Dealer, Sydney,
May/June 2000

Fred Williams Pilbara Series
by Bala Starr and James Mollison,
The Ian Potter Museum of Art,
University of Melbourne, June 2000

Visions of Australia 1950 – 2000
Nevill Keating Pictures Ltd., London,
UK, July 2000

The Enduring Landscape:
Gouaches By Fred Williams
Monash Gallery of Art, Victoria,
December 2000 – January 2001

Fred Williams and the National
Gallery of Australia
by Anne Gray, *Artonview*, National
Gallery of Australia, Canberra, Issue
No. 31, Spring 2002

Australian Art in the
National Gallery of Australia
by Anne Gray, National Gallery of
Australia, Canberra, p. 276; 2002

Fred Williams: The Pilbara Series
by Jennifer Phipps and Kirsty Grant,
The National Gallery of Victoria, 2002

Bone Beneath The Skin, and Spirit:
Sid Talks With Albert, Rover,
Colin and Fred
by Daniel Thomas, *Art Monthly*
Australia, No. 164, pp. 22-26,
October 2003

FRED WILLIAMS:
AN AUSTRALIAN VISION
BRITISH MUSEUM, LONDON, UK,
DECEMBER 2003 – APRIL 2004

Fred Williams, An Australian Vision
by Irena Zdanowicz and Stephen
Coppel, The British Museum/
Thames & Hudson Ltd., UK, 2003

Hit Parade
by John Russell Taylor, *The Times*,
London, UK, p. 14, December 24, 2003

Unheroic Australian
by Laura Gascoigne, *The Spectator*,
London, UK, January 31, 2004

Broader Focus on
Visions of Fred Williams
by Sasha Grishin, *Canberra Times*,
May 29, 2004

Far Horizons
by Simon Brett, *Printmaking Today*,
London, UK, Vol. 13, No. 2,
Summer 2004

Fred Williams, An Australian Vision
by Irena Zdanowicz and Stephen
Coppel, *Printmaking Today*,
London, UK, Autumn 2004

Fred Williams
by Peter Nahum, *Print Quarterly*,
London, UK, September 2004

Celebrating Fred Williams:
Seven new gouaches in the gallery
give us good reason to do so
by Hendrik Kolenberg, LOOK Art
Gallery Society of New South Wales,
Sydney, 2004

FRED WILLIAMS: WATER
McClelland Gallery and
Sculpture Park, January 2005

Splendid Isolation: A detailed
immediacy provides new reasons
to fall in love with Australia's
greatest painter all over again
by Sebastian Smee, *The Weekend*
Australian, Sydney, pp. R14-15,
January 8-9, 2005

When Oil and Water Mix
by Peter Hill, *The Age*, Melbourne,
February 8, 2005

Videography/Multimedia

Printmaking
dir. Lloyd Capps, Australian Broadcasting
Commission, Melbourne, August 1971

TEN AUSTRALIANS/
DIX ARTISTE AUSTRALIENS
CONTEMPORAINS
Musee d'art Moderne de La
Ville de Paris, France,
November 1974 – January 1975
Traveled to Germany, Italy,
UK and Art Gallery of New
South Wales, 1975

Ten Australians: Fred Williams
dir.s Stafford Garner and Dale McCrae,
Australian Broadcasting Commission &
Visual Arts Board of the Australia
Council, VHS, 30 mins., February 1975

Fred at MOMA
Melbourne Australian Broadcasting
Commission TV, VHS, June 21, 1977

The Australian Eye Series:
Contemporary Painting 1950-79;
Fred Williams: Waterfall Polyptych
Australian Broadcasting Commission,
Education Department of New South
Wales and Film Australia, 10 mins., 1979

Interview with Patrick McCaughey
by Traudi Allen, Landline, 3AR/ABC
Radio, February 1982

Showbiz, Patrick McCaughey
Interview by Veronique Bernard,
Fred Williams: The Artist and
His Work
SBS TV, 5 mins., October 1987

Fred Williams Works, (52 Slides)
National Gallery of Victoria,
Melbourne, 1988

Fred Williams: Landscape
Christian Television Association,
Channel 9, 90 secs., October 1988

Patterns of Landscape,
Fred Williams 1927-82
dir. Christina Wilcox, Film Australia,
VHS, 46 mins., 1989

The Art of Fred Williams, Slide Kit
Victorian Education Department
Melbourne, 1993

Official Fred Williams Web Site
http://fredwilliams.me.com.au/

Exhibition Checklist

Kew Billabong, Old Tyre II
1975 OIL ON CANVAS
42 X 36 1/4 INCHES
106.7 X 92 CENTIMETERS
SIGNED UPPER LEFT

Golden Landscape
1975 OIL ON CANVAS
40 X 40 INCHES
101.7 X 101.7 CENTIMETERS
SIGNED LOWER LEFT

Silver Landscape
1975 OIL ON CANVAS
40 X 40 INCHES
101.7 X 101.7 CENTIMETERS
SIGNED LOWER RIGHT

Dry Creek Bed (Werribee Gorge Series)
1976 OIL ON CANVAS
48 X 48 1/8 INCHES
122 X 122.2 CENTIMETERS
SIGNED UPPER RIGHT

Lysterfield Paddock, Woodstacks
1977 OIL ON CANVAS
36 X 42 1/8 INCHES
91.5 X 107 CENTIMETERS
UNSIGNED

Reflected Tree Trunk,
Kew Billabong, *Diptych*
1978 OIL ON CANVAS
33 7/8 X 75 3/4 INCHES
86.1 X 192.4 CENTIMETERS OVERALL
33.875 X 37 INCHES EACH
86.1 X 96 CENTIMETERS EACH
UNSIGNED

Strath Creek Falls III
1979 OIL ON CANVAS
42 X 37 7/8 INCHES
106.7 X 96.2 CENTIMETERS
SIGNED LOWER LEFT

Coliban Falls I
1979 OIL ON CANVAS
42 X 37 7/8 INCHES
106.7 X 96.2 CENTIMETERS
SIGNED LOWER LEFT

Agnes Falls I
1979 OIL ON CANVAS
41 7/8 X 37 7/8 INCHES
106.5 X 96.2 CENTIMETERS
SIGNED LOWER RIGHT

Lal Lal Falls III
1981 OIL ON CANVAS
71 7/8 X 60 INCHES
182.5 X 152.4 CENTIMETERS
SIGNED LOWER RIGHT

Pool at Agnes Falls II
1981 OIL ON CANVAS
59 7/8 X 72 INCHES
152 X 182.2 CENTIMETERS
SIGNED LOWER RIGHT

Rockface at Agnes Falls IV
1981 OIL ON CANVAS
72 X 60 INCHES
182.8 X 152.4 CENTIMETERS
SIGNED LOWER RIGHT

Shadow Under Red Cliff (Pilbara Series)
1981 OIL ON CANVAS
48 X 47 7/8 INCHES
122 X 121.5 CENTIMETERS
SIGNED LOWER RIGHT

Iron Ore Landscape (Pilbara Series)
1981 OIL ON CANVAS
37 7/8 X 42 INCHES
96.2 X 106.5 CENTIMETERS
SIGNED LOWER RIGHT

Morning Landscape (Pilbara Series)
1981 OIL ON CANVAS
38 X 41 7/8 INCHES
96.5 X 106.5 CENTIMETERS
SIGNED LOWER RIGHT

Coastline (A)
1981 OIL ON CANVAS
71 7/8 X 59 7/8 INCHES
182.5 X 152.1 CENTIMETERS
SIGNED UPPER LEFT

Riverbed (C)
1981 OIL ON CANVAS
71 7/8 X 59 7/8 INCHES
182.5 X 152.1 CENTIMETERS
UNSIGNED